D0961866

animal antics

animal antics

A PHOTO EXPOSÉ BY JOHN LUND

**Andrews McMeel
Publishing**

Kansas City

Animal Antics copyright © 2002 by John Lund. All rights reserved. Printed in Hong Kong. No part of this book may be used or reproduced in any manner whatsoever without written permission except in the case of reprints in the context of reviews. For information, write Andrews McMeel Publishing, an Andrews McMeel Universal company, 4520 Main Street, Kansas City, Missouri 64111.

03 04 05 06 KWF 10 9 8 7 6 5 4 3

ISBN: 0-7407-2700-1

Library of Congress Control Number: 2002103760

Book design by Propel Design

Attention Schools and Businesses
Andrews McMeel books are available at quantity discounts with bulk purchase for educational, business, or sales promotional use. For information, please write to: Special Sales Department, Andrews McMeel Publishing, 4520 Main Street, Kansas City, Missouri 64111.

introduction

What you hold here in your hand is the photographic proof of what you've long suspected—that behind our human backs, the animals of the world are living secret, fun-filled lives.

Those animals that you think are quietly going about their everyday business are actually leading rich, private lives filled with pleasure. Whether it's dogs enjoying a challenging game of poker, cats dancing the cancan, or dogs and cats playing Twister together, they reveal the secret of reveling in the joy of being alive. They know how to live for the moment and enjoy the fun that life has to offer, and they can inspire us silly humans to do the same.

By taking a peek into these creatures' most mischievous and blissful moments, *Animal Antics* imparts a true reflection of the hearts and minds of our animal friends. The truth is, of course, that animals are much more like you and me than we ever imagined.

If animals could, this is what they'd tell us.

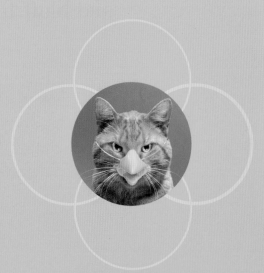

Know when to hold 'em, know when to fold 'em,
and bluff like a bulldog.

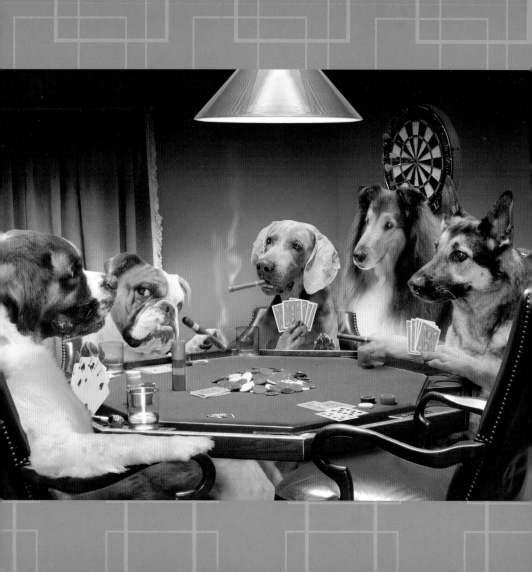

Share a good laugh.

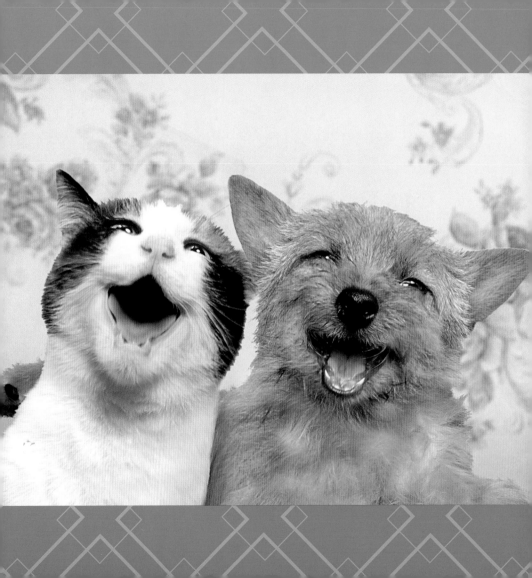

Party till the cows come home.

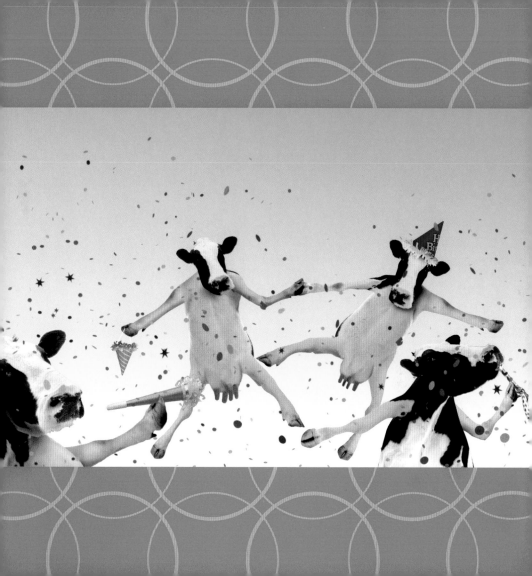

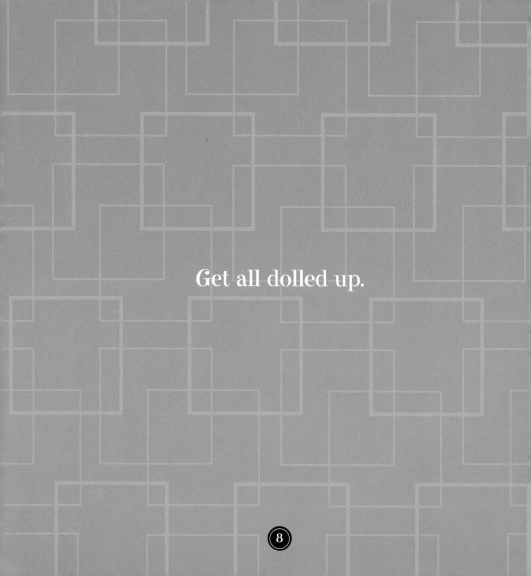

Get all dolled up.

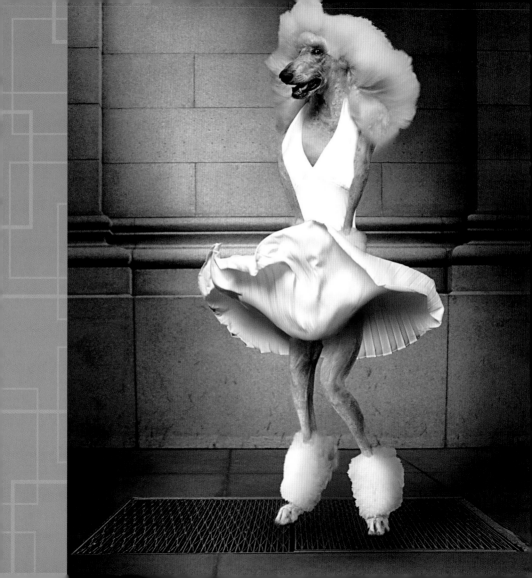

Know that friends who work well as a team reap the rewards.

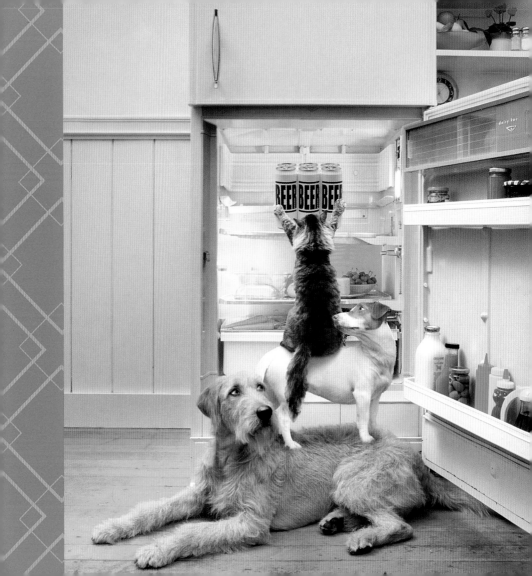

Always go for la crème de la crème.

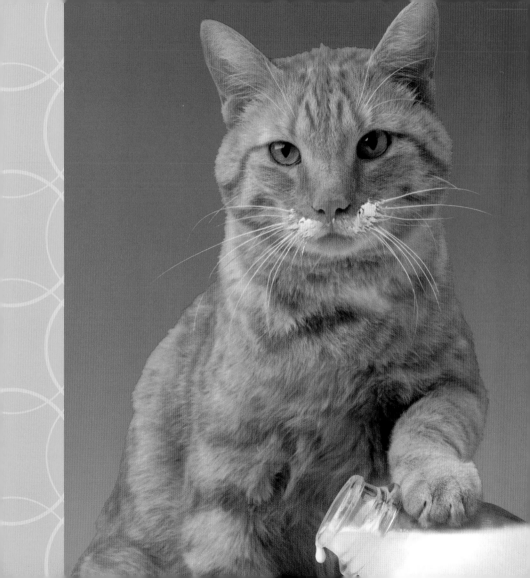

Realize that friends come in all sizes . . .

14

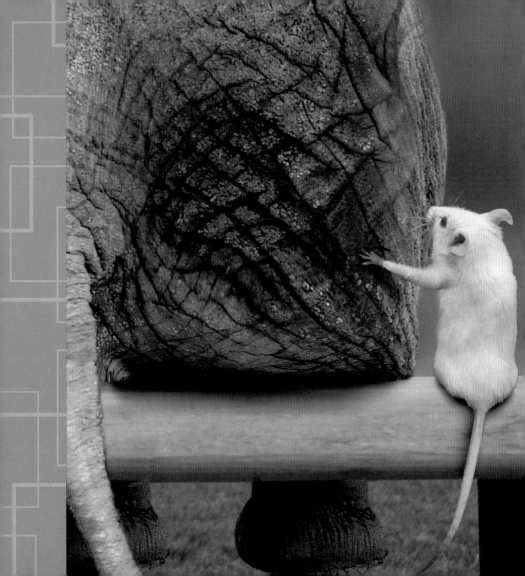

and each size fits perfectly.

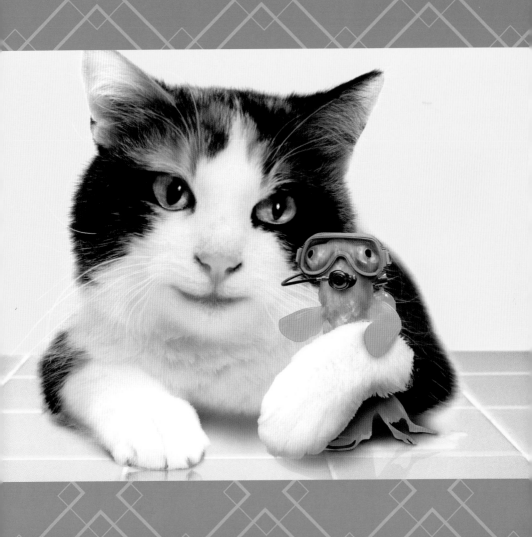

Appreciate your own special talents . . .

18

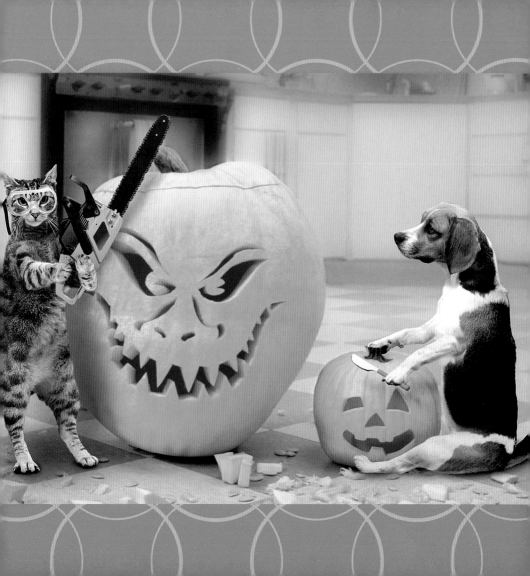

and share them with those you love.

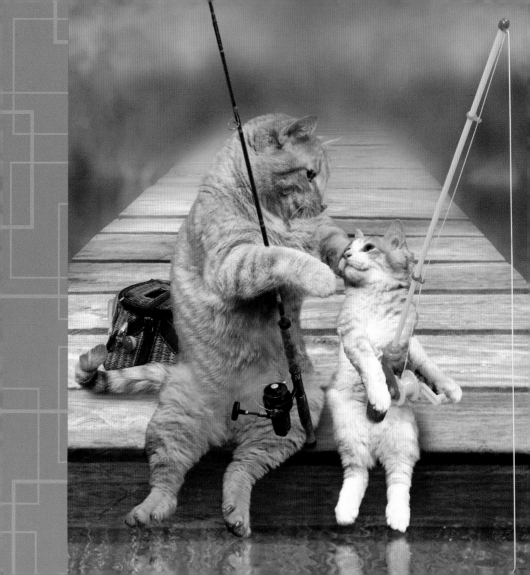

Always join in a cancan . . .

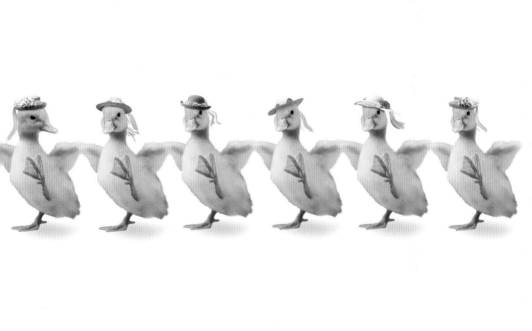

especially when it's a catcancan.

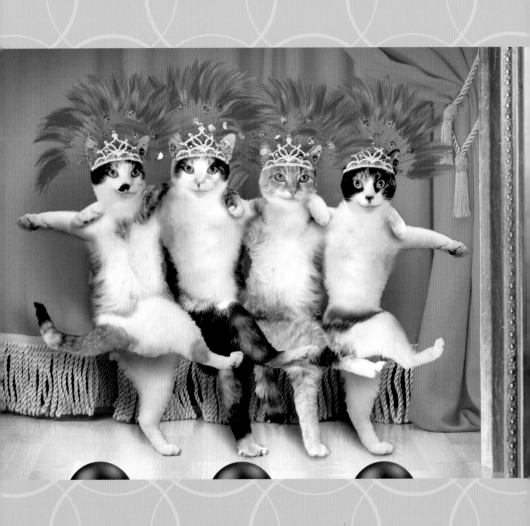

Admit your shortcomings, even if it means
confessing a canibunal act.

26

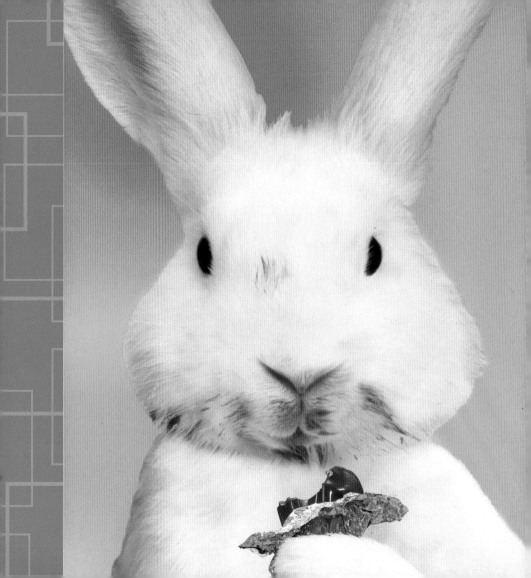

Howl together for the holidays.

28

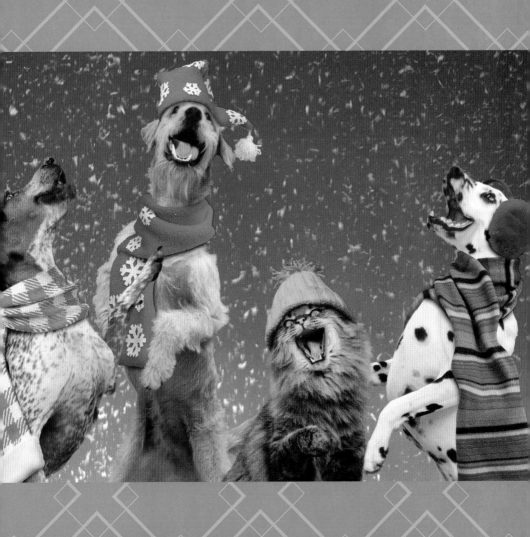

Know that victory feels wonderful . . .

30

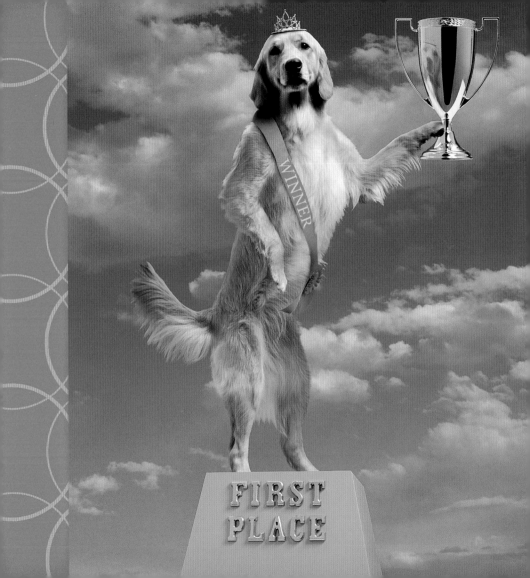

FIRST
PLACE

and that a little respect really can save the day.

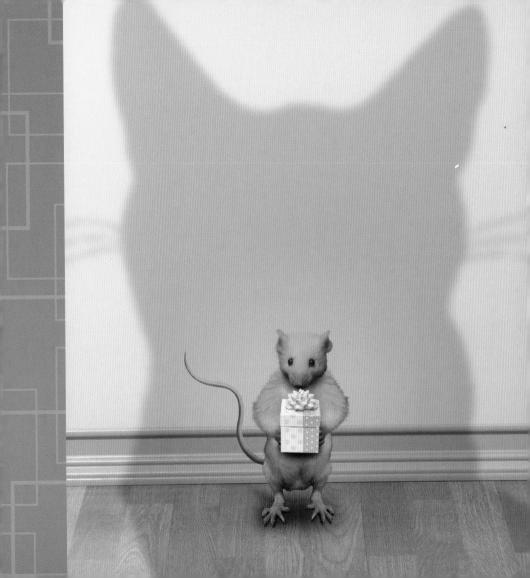

Learn to pamper your soul (and your paws).

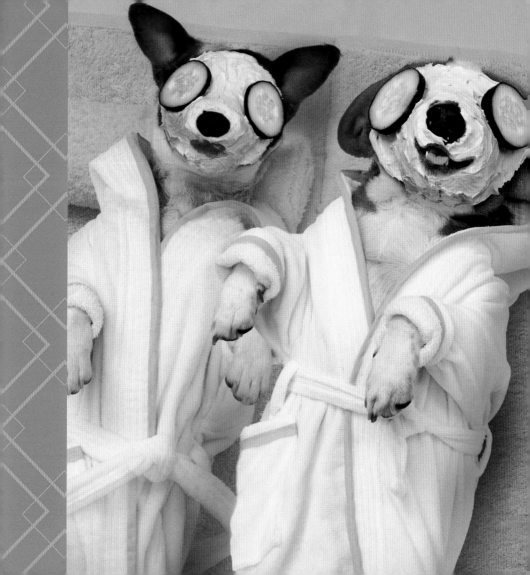

Delight in being queen.

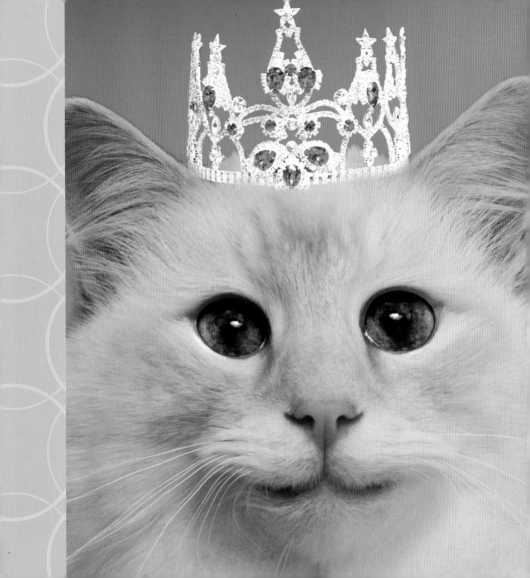

Always tell it like it is . . .

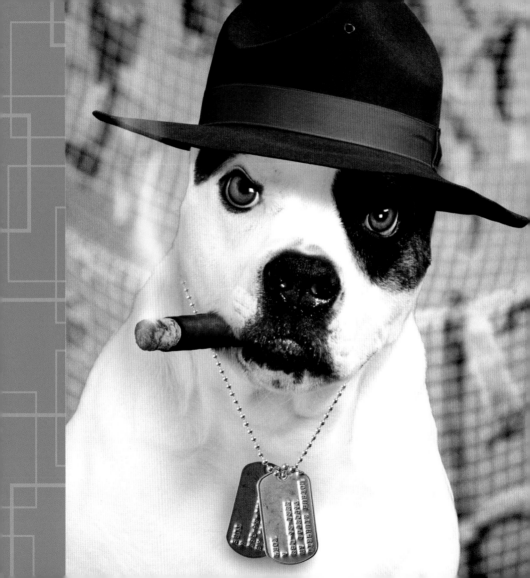

and say "Thank you very much" a lot
(and to many!).

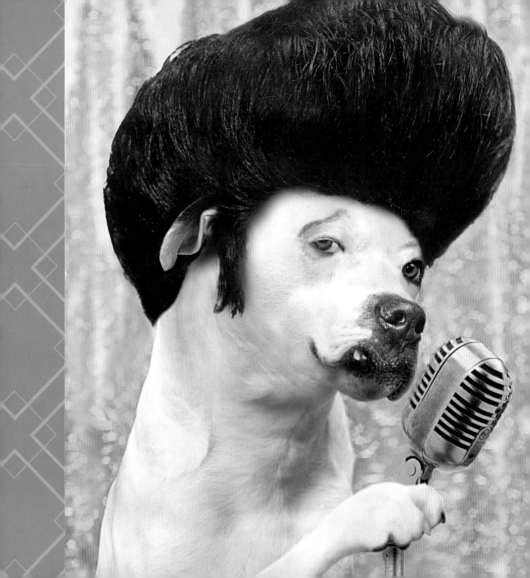

Hang with your buddies . . .

42

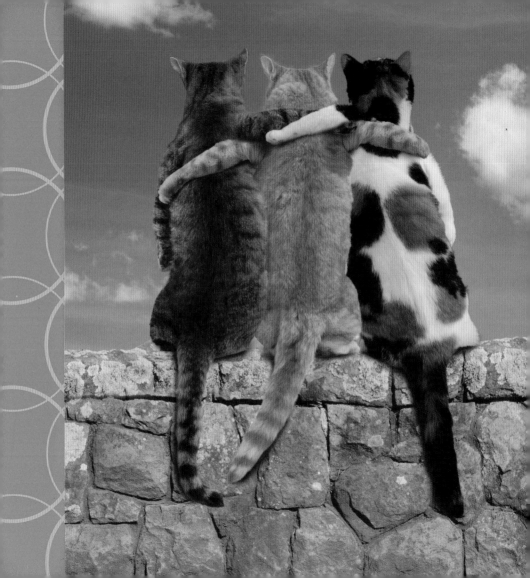

fly with your friends . . .

44

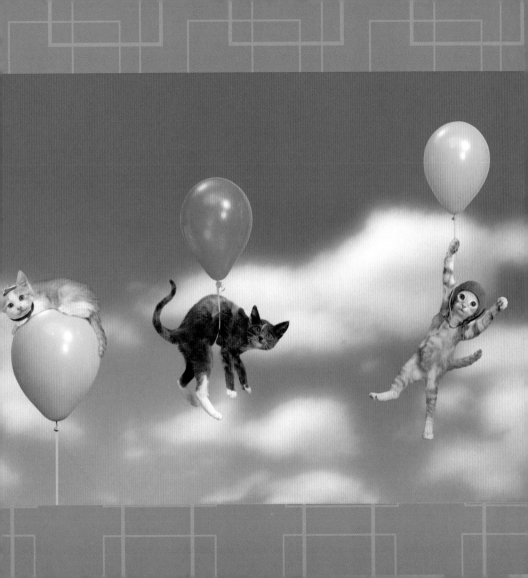

and chill out as needed.

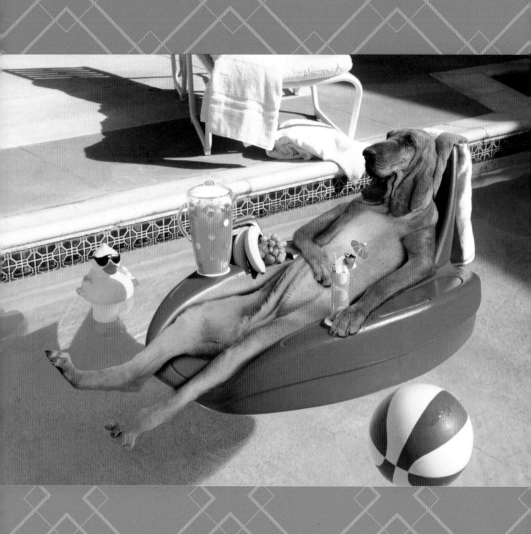

Add a little surprise to someone's day.

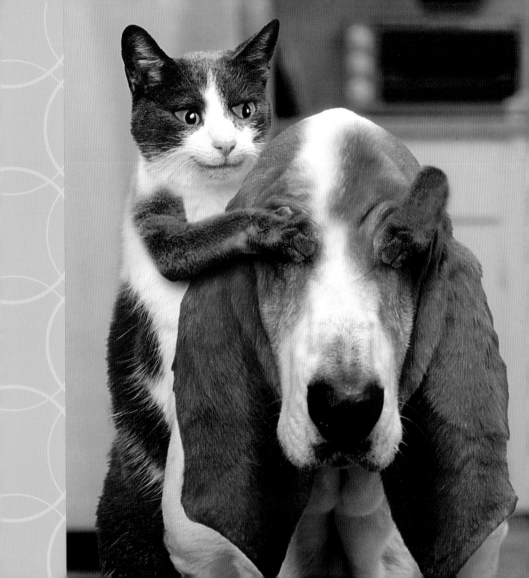

Think big—**way** big.

50

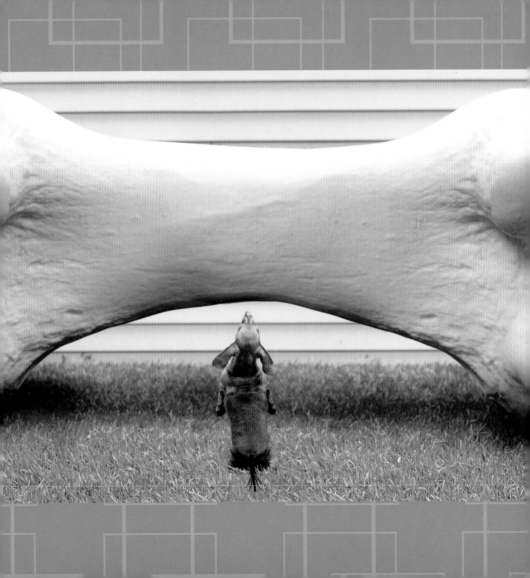

Never pass up the opportunity for a joyride.

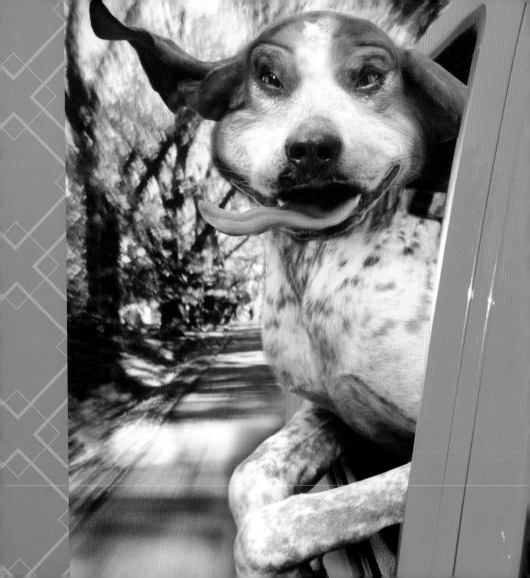

Play with your friends . . .

54

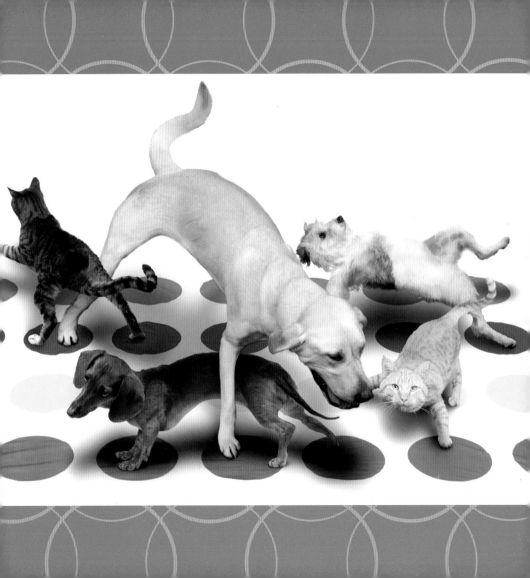

enjoy spinning your wheels . . .

56

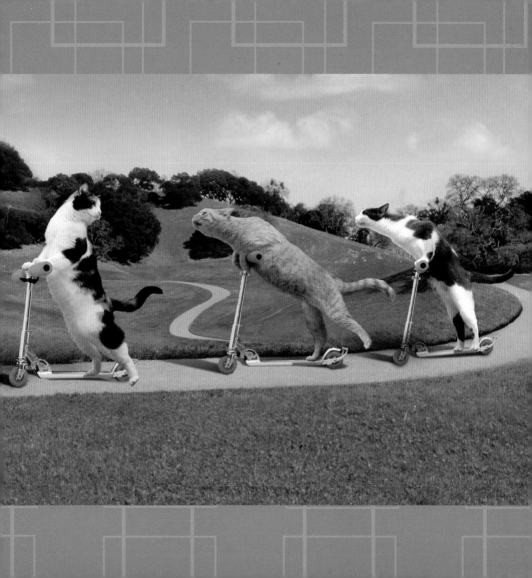

and have good fun with each other.

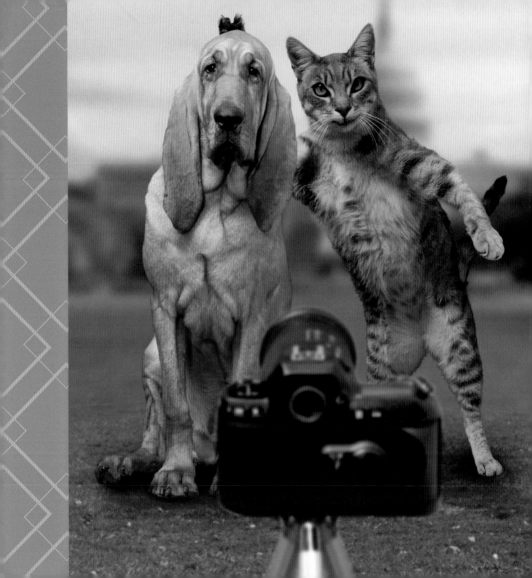

Realize that some of us are incapable
of keeping a secret . . .

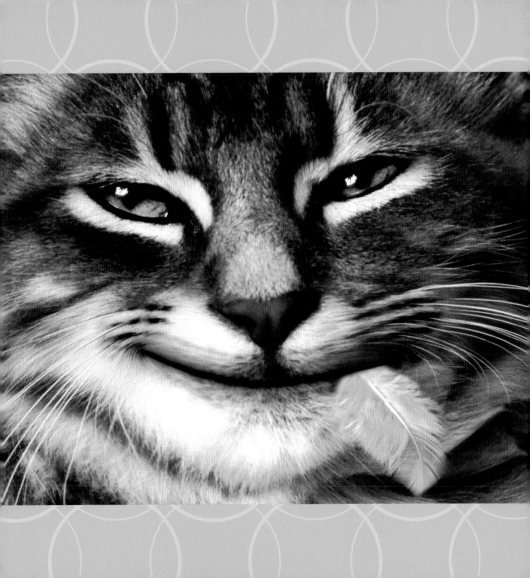

and that others aren't nearly as secretive
as they'd like us to believe.

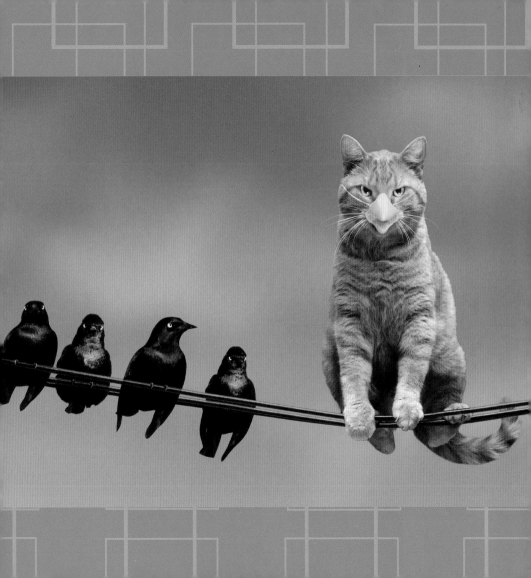

Don't ever be shy of asking for advice.

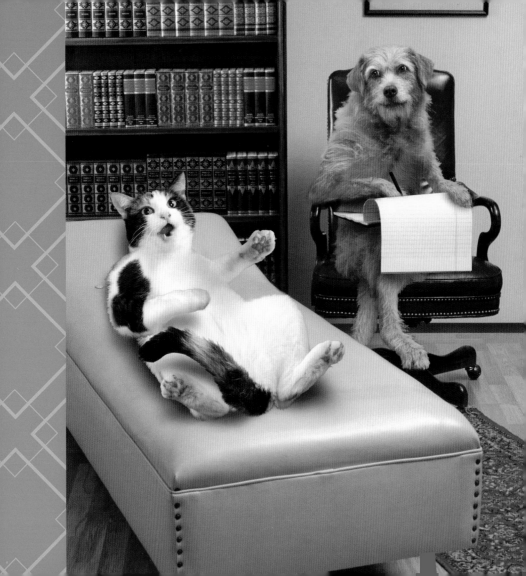

Sharpen your survival skills . . .

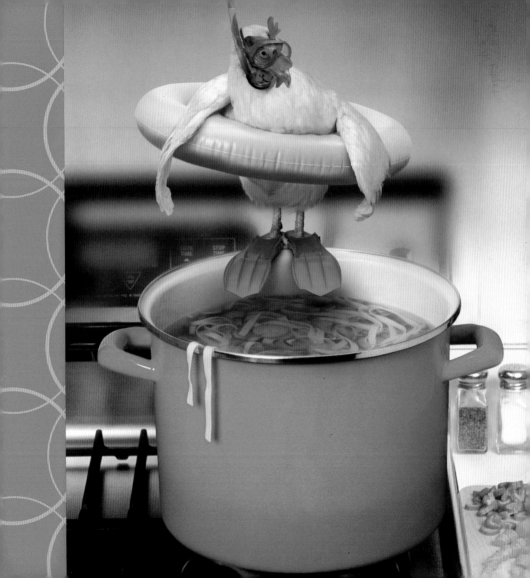

and learn how to protect yourself.
(You never know when you'll run into a rogue.)

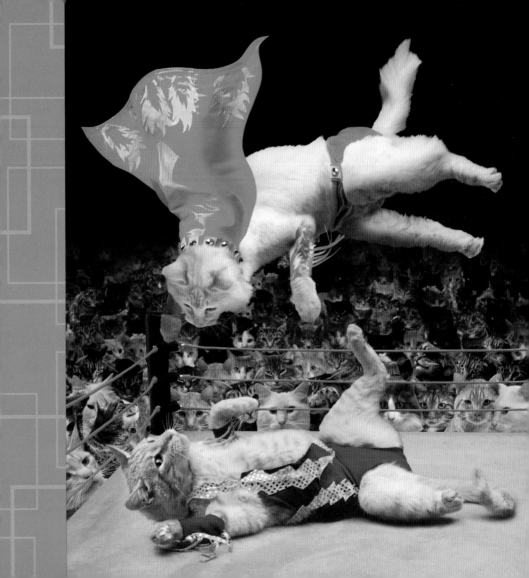

Share quiet moments with your loved ones.

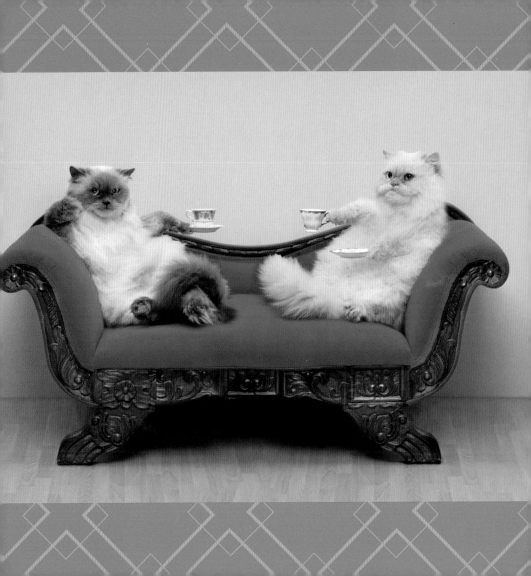

And most of all . . . live it up.
After all, we cats get nine lives,
but you humans only get one.

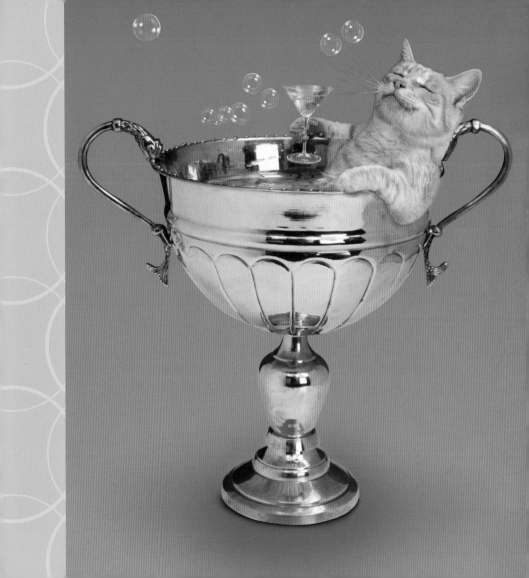

Special thanks to Collette Carter and Peter Stein, whose creativity, energy and enthusiasm have been vital in creating these images.